THE
CALLiGRAPHY
OP

THE

CALLiGRAPHY

SHOP

Ben Downing

Zoo Press

Zoo Press • P.O. Box 22990 • Lincoln, Nebraska 68542
Printed in the United States of America

Distributed to the trade by The University of Nebraska Press
Lincoln, Nebraska 68588 • www.nebraskapress.unl.edu

Cover design by Janice Clark of Good Studio © 2003
www.goodstudio.com

Downing, Ben, 1967-
 The calligraphy shop : poems / by Ben Downing.-- 1st ed.
 p. cm.
 ISBN 1-932023-09-7 (pbk.)
 I. Title.
 PS3604.O689C35 2003
 811'.6--dc22
 2003016876

zoo16

First Edition

Acknowledgments

The author gratefully acknowledges the publications in which the following poems appeared:

AGNI: "Bicoastal"; *The Antioch Review*: "An Amateur Barbarian"; *The Atlantic Monthly*: "Inshallah"; *Columbia*: "The Sideways Medusa"; *The Nation*: "Little Palinode"; *The New Criterion*: "Tempocide," "The Civil Wars," "The New Parnassians," and "Fontanelle"; *The Paris Review*: "One Green Stone," "Hiroshima Without Adjectives," "The Calligraphy Shop," and "The English Are So Nice!"; *Parnassus: Poetry in Review*: "Fermat's Last Theorem" and "Two Husbands"; *P.N. Review*: "Aeolian Kazoo"; *Poetry*: "Onomathesia," "Saudades," and "Pangur Blah"; *Poetry Ireland*: "Sortes Virgilianae" and "On First Looking into Bate's Life of Johnson"; *The Southwest Review*: "The Aged Phoenix"; *The Yale Review*: "No Rosetta Stone."

"The Sideways Medusa" and "The Calligraphy Shop" were reprinted in *Descant* (Canada).

"The Mixer," "One Green Stone," "Saudades," "Prothalamion," "Inshallah," "Aeolian Kazoo," "Hiroshima Without Adjectives" and "The Calligraphy Shop" were reprinted in *New Poetries III* (Carcanet Press, U.K., 2002).

"The English Are So Nice!" was reprinted in *The Paris Review Book of Heartbreak, Madness, Sex, Love, Betrayal, Outsiders, Intoxication, War, Whimsy, Horrors, God, Death, Dinner, Baseball, Travels, the Art of Writing, and Everything Else in the World Since 1953.*

for Michele

Table of Contents

No Rosetta Stone

No Rosetta stone is needed here,
no basalt slab to bridge the dialects
between us. My hermetic alphabet
(a crux for some) comes legible, then clear

to you, just as your cryptic glyphs, my dear
Egyptian scribe, make a sense more delicate
than any Greek to me. A middle lex
of gist and balderdash being what we share,

I say let us talk our little talk,
jape, palaver with impunity,
because how rare, never to be struck

down and dumb beneath another's tongue,
nor left illiterate, without the key
provided by our inside idiom.

Tempocide

I tried to kill time but it would not die.
No sooner had I whacked its weeds than they
sprang tauntingly back up, revivified
by some artesian strength inside the day.
Its past I stabbed, then laced with cyanide
the golden sundials for its greedy rays—
fiascos both. My attempt, while driving by,
to catch the minutes in a fusillade
of disregard; my fiendish plot to elide
unwanted hours just dawdling them away;
the clock-shaped voodoo doll; the evil eye
against my watch; calendars auto-da-féed:
all these and others went risibly awry,
so botched and feeble were my ambuscades.
The more I hacked, in fact, the more time's hy-
dra heads came unwinding out to prey,
their long antagonisms multiplied
and whetted by such treacherous essays.
From tick to tock now seemed an ocean wide;
a googolplex of nanoseconds weighed
upon me crushingly. Helpless then to pry
loose time's awful bulk or to delay
its reckoning, nabbed without an alibi,
a sorry-assed assassin *tout à fait,*
I wished I'd let time be and wondered why
we try to kill what passes anyway.

On First Looking into Bate's Life of Johnson

I.

I knew beforehand, Sir, of your scintillant
bons mots and persiflage, the aplomb
with which you scuppered those poor schmucks who went
haplessly against your grain or glommed

onto the wrong ideas. From Boswell
I learned, previously, of your pawkiness,
your draggletail's disdain for proper dress,
all about your glancing bagatelles.

And from perusal of your own works I
had already come to venerate the high
gloss you put on things, your peerless prose
with its lapidary dominoes

augustly toppling, clause after clause
unspooling like the costliest kilim
to welcome us in. Your full avoirdupois
I had presumed to feel, Gruff Pachyderm.

II.

But not until realizing what odds
you strove so valiantly against, what flak
you gave yourself, and how often the black,
ill-mannered ox across your cornfields trod

could I take (or approximate, at least)
the true, heroic measure of your mind.
You seem to me that much more a Heracles
for having overcome the saturnine

declivities that were your gloomy wont;
knowing your weakness, I grasp how paramount
your power really was. To keep *indolence*
—a favorite word, a dreaded fer-de-lance—

at bay, you had to waddle about and *crowd*
(another one) your days with busyness.
Has anyone, for fear of doing less,
done more to make his jealous Maker proud?

III.

And then there are your fine solicitudes,
so many and diverse: all you did to see
your old wife Tettie through her sunken moods
and death; your domestic "menagerie"

(as Macaulay dubbed it) of the cast-off,
forlorn, and homeless, who filled your rooms
and wolfed your grub; those mendicants for whom
you always had condolent words and sloughed

the meager lucre of your pockets out,
"to enable them," you once said, "to beg *on*";
the former slave you decided to adopt
in sticking with your call for abolition;

the countless hacks on whom, outpounding Pound,
you let the boon of prefaces redound;
Milton's granddaughter, whose benefit
you organized; fresh oysters for your cat.

IV.

Professor Bate has served you faithfully
despite being an American.
As you once ambered others, he has spun
a grease-stained halo round your memory,

embalming you in neither the debauched
fluids of the ordinary Joe
nor the priggish ether of the hagio.
Half slob, half saint: your corpulence was lodged

between the rock of faith and the hard spot
of being merely human—a Gordian knot
which you, no Alexander, couldn't cut,
yet worked and worried in such intricate,

persevering, poignantly futile ways
that your greatness beggars his. Epitome
of Adamites, the ur-Dr. J,
your frazzled life here finds a natty peace.

Saudades

is what my student said he'd feel for me
upon returning to Brazil, and how
he felt right then, in fact, about the place
he'd left behind. He spoke the word as if
it were the loneliest, most dignified
sound that human tongues had ever wrapped
themselves around, his face aflame with that
peculiar pride in the untranslatable.
But still we tried to find some semblance
of an English shape: a pining when applied
to absent people, or homesickness
where the land's at stake. And although I
—who had no Portuguese—could only take
from him a faint, imperfect imprint, I press
it here for you to see, knowing as I do
that *love* in any language comes out clear.

Inshallah

—which is to say "God willing," more or less:
a phrase that rose routinely to her lips
whenever plans were hatched or hopes expressed,
the way we knock on wood, yet fervently,
as if to wax too confident might be
to kill the very thing she wanted most.

It used to pique and trouble me somehow,
this precautionary tic of hers, but now
I understand why she was skeptical
of what Allah in His caprice allots,
because that she should live He did not will,
or, more terribly, He did that she should not.

i.m. Mirel Sayinsoy 1967-99

One Green Stone

*...celui qui trouve son emploi dans
la contemplation d'une pierre verte...*

—St.-John Perse

He who finds his business in the slow,
persistent study of one green stone,
even a plain one chosen, let us say,
from a plenitude of greater green;

and who, in choosing green, abandons blue
to its own scholar, snubs all reds, rejects
the dark persuasions of persistent black;
and whose choice of stone as well reflects

the surface of a world neglected—not
without pain, but without regret—of things
crying out their equal worth, their need
to have their facets noted, diamond rings

and the humblest wooden chair alike
in the futile clamor of the claims they make
upon the student who, studying his one
green stone, considers that, and that alone.

Little Palinode

The one in which I figured love as cur,
yowling and prideless; that regrettable,
forgettable sestina, taking for

its teleutons the six thorns of womankind;
my broken crown of bitter sonnets,
each a crude jewel cut from...never mind;

the necrophilic epic of my youth;
Agamemnon's Legacy; the one whose sharp
barb I tore from Lear: "A serpent's tooth...";

and all those I never wrote, but *willed*,
the million daily savageries we pen
invisibly against ourselves, the chill

annals of distance filling up with doubt,
unbridgability, a history
of closeness killed—I hereby turn about,

recanting every can't, the should have beens,
every wistful would and could, to speak instead
a rock-sure poem of the present tense,

the kind of lines in which a man can say,
with confidence, the little words that count:
you are, I am, this is, right now, right here, stay.

Pangur Blah

I and Pangur Ban my cat,
'Tis a like task we are at;
Hunting mice is his delight,
Hunting words I sit all night...

(found in the margins of a 9th-century Irish manuscript)

The woeful difference now is that
it's I who mouse and not my cat,
or rather I who listlessly
swat prey around my pad while he,

an urban beast (hence unemployed),
does naught but nap and shed and void;
bugs are all he gets to bite,
the sporadic phrase is all I write.

A melancholy pair we make:
I without a line to break,
my limp grimalkin rodentless,
superfluous the both of us.

And so we stew in this our dumb,
indolent scriptorium,
whose air is cleft by sighs and creaks
yet never once that fateful squeak.

The Mixer

Our moods do not believe in each other.

—*Emerson*

How true. And so, having vowed to introduce
my skeptical own, I planned a splashy fête,
then worked through my black book's alphabet:
Abjection, Humdrum, Mr. Perky, Zeus

(as Drug-Fueled Cockiness styles himself these days)
were all pressed warmly to my posh soirée.
The whole thing went swimmingly—at first.
Impatience huffed in early, fretted, cursed

the tardy guests, but settled down when Mellow
administered shiatsu. The same
effect was had by Thoughts of Long Ago
on Dwelling in the Future: each became

the other's palliating complement;
a jolly pair they made, equivalent
together to Atop the Moment's Wave,
who had begged off. Lookin' to Misbehave

ducked sheepishly back into line when faced
with the righteous mug of Good Samaritan;
Glad hugged Sad; Mad took a pill. But then,
when Bumptious Dickhead started to lambaste

the Soul of Thoughtfulness, the atmosphere
queasily curdled and reversed itself.
The Four Humors came as one, snickered, jeered
the junior metaphors; Rude Aerobic Health

leapt to their defense; Atrabile got spilled;
Choleric oozed across the floor and kindled
High Dudgeon, who'd been stewing in his chair,
abruptly into Rabid. Everywhere,

it seemed, a mood now trounced its opposite,
behaviors with their loathed antipodes
squared violently off: What Will Be
Will Be and Seize Control of Your Own Fate,

Hunkydory pistolwhipped by Fuck the World,
Thin-skinned v. Unflappable, Sourpuss
contending Chipper, Genteel with Churl,
fisticuffs twixt Tightwad and Magnanimous,

Kinky humping Prude, Laodicean
by Zealot gruesomely crucified,
with Hamlet, Pangloss, Calvin with Wilde,
the Draco in me punishing the King,

and all, of course, ganging up on Paranoid;
not even Blah quite managed to avoid
the brutal fray of temperaments.
Eventually, the warring parties spent

themselves, desisted grudgingly, and left,
each to his remote sarcophagus.
I paused; and next, both Relieved and Bereft
(loyal chums, they'd stayed behind), began to suss

my curious situation out. They'd met,
irrefutably, and fought, loved, swived,
abominated, swapped gossip of my lives,
snubbed, empathized, flouted Etiquette.

The raucous proof was iron-clad, I thought:
those phantoms at whose substance they'd once scoffed
had been made real for them far past dispute.
No longer could they hoist their haughty snoots

disdainfully above their brethren;
besides, I mused, they have in common *me*.
Isn't that enough? You'd think they'd want to bend
their passions to my central peace, agree

on some hybrid, ideal specimen,
neither Grim nor falsely Debonair,
not Tart, not Saccharine, but measured, fair,
and sleekly fitted to the subtle end

of animal satiety. Alas.
So little's changed. My selves go blithely on
as if they'd never butted heads or razzed
their Manichaean twins, as if beyond

their meager pale lived only reprobates
instead of what I'd shown: valid traits
clobbering yet buttressing their own—
quel paradoxe. Each still swears that he alone

exists, has claim to me, is singular,
supreme, nonrelative, and permanent.
And who am I to doubt such wisdom when
I am the Bittersweet whose sum they are?

Prothalamion

The *cleaving* properties of love
(in both conflicting senses of

that Freud-deflowered word: to split
violently; bindingly to knit)

are such that every one becomes,
by action of its medium,

 either halved or magnified.
 While the harder meaning I'd

more often met with in the past—
the sundered pride, the heart crevassed—

its stronger valence now cements
those parts of me that had been rent,

and melds them with your own bits till
we're alloyed in love's crucible.

Two Husbands

i)

The opposite of Prospero,
Rossetti disinterred his book.
Those sonnets he'd consigned below,
trussed up so fondly with a lock
of his wife's lamented golden hair,
now seemed to him a pentateuch,
a very grimoire rashly buried.
With ghoulish verve he undertook
his mouldered volume to retrieve,
then published it to much acclaim.
One moral is you shouldn't leave
the things of love with those of fame,
confusing them in coffinwood;
another's that you damn well should.

ii)

To bolt in shock, as Ruskin did,
on meeting with a hirsute mons
might seem a radical response.
But when you think that caryatids,

demure madonnas, glabrous nymphs
were all he'd known of womankind,
it's no surprise that he should find
his own endowment going limp,

eclipsing thus his honeymoon.
Poor John, he's taken heat enough
for having failed before the muff.
Yet who among us dare impugn

his quaint ideal of furlessness?
Who can endure, with firm sangfroid,
the finding of some beastly flaw
in one's anticipated bliss?

His case enjoins us to forswear
the perfect flesh unfollicled
and to accept, once and for all,
that everything in life has hair.

Fontanelle

...so called because it shows a rhythmical pulsation
produced by the flow of blood in the vessels of the brain.

—*Webster's*

The boggy spot atop her skull,
which would at birth accommodate
the whole pad of my thumb, of late
has disappeared—parietal

bones now fused into a full
and obdurate concavity.
How comforting to know that she
no longer is so vulnerable,

at least in that one crucial place.
But part of me half-misses it,
the chink in her small basinet,
and tempts me almost to embrace

the crackpot views of those poor nuts
who have nostalgically trepanned
themselves, or had themselves trepanned;
by drilling through their sinciputs,

they draw more blood into the brain
—supposedly—and thus restore
the magic buoyancy of yore,
that infantile, Wordsworthian

consciousness extinguished by
the closing of their crania.
No need for such a mania,
however, since already I

detect that some new aperture,
pierced in me when she was born
as if by tiny unicorn,
has widened out in pace with her

own portal's slow diminishment.
I sense it, this phenomenon,
not in my head but lower down:
a fluttering thoracic vent

that, artesian, lets feeling well,
then pumps it forth in measured spate
to course and lap and irrigate
—a kind of second fontanelle.

Pieces of Pangaea

The way the pieces of Pangaea
parted once and scattered, each land
dispersed upon its plate,
is how, Plato reasoned, the whole
human suffered Zeus's splitting,
down along the shifting so that still today we're drifting
fractures of our faults, inching
India's dagger deeper
into the Himalayan heart,
or in search, like Africa,
of South America's Jurassic coast.

Aeolian Kazoo

Not the dulcet harp of Thomson, Coleridge,
et al. I can't afford the ormolu,
the pretense of the wind god whiffling through
in celestial puffs, a kapellmeister midge

at work for me, pluck pluck, among the strings.
Such instruments are fickle, hothouse things;
you might put one before a *khamsin,* say,
which Brewer salutes as "a fifty days'

wind in Egypt," and scarcely cop a plink
therefrom. *Pampero, harmattan,* and *mistral:*
none can make a troubadour or prink
the tin-eared poetaster's caterwaul.

I, for instance, took my verse box to Peru,
held it in the snapping *puna* gale,
and didn't get so much as doggerel.
Which is why I've traded down to this kazoo,

this rude, barbaric tube whose only note—
a raspberry, Bronx cheer, or lusty troat
chortled by some rutting pinniped
from hell—will sound, if dunderheaded,

at least reliably with every wheeze.
An afflatus stalwart as a caravel
is what I need, one undaunted by the *bise*
of despondency and sloth—no Philomel,

perhaps, but also no fantastic roc
or wild goose gulling me loose from gravity.
Enough of being the zephyrs' shuttlecock,
the passive frisbee of velleities,

a New Age porch chime tinkling in Marin.
Swatted, lofted, jiggered like a kite? Fuck that.
Gimme a strapping muse to insufflate
my lungs with common air, wipe the Hippocrene

bubbles from my mouth—a lifeguard muse of meat
and homefries, not ambrosia, with blood
instead of ichor in her veins. Effete
Parnassians, vamoose: the old amplitude

of paranormal sponsorship has shrunk,
quaint casualty of our vogue to debunk
the very credences that once sustained
these rhapsodies. The wind is now the wind

is just the prolix, tenantless breeze;
a quondam host to pixie orchestras
who played us adventitiously because
we expected them to, its deities

have skedaddled like a rock band breaking up.
Therefore I take my dime-store didgeridoo,
my little pipe of homeliness, my Jew's
harp galumphing out its squawky bop,

my poor kazoo, and, disgrace to Jubal
that I am, honk away without *sirocco*
or buff *nor'easter* in my sails. After all,
as the Latin saw goes, "When there's no wind, row."

Bicoastal

Such splitting distances as these we make
reluctant home and habit of, such weak

transmissions slipping down the optic thread—
that vile hoax of visibility we dread

as much as need. There's sleet enough to test
the postman's swift completions here; back west,

meanwhile, San Andreas' plates grind out
his hagiography, a tale about

the rending of a beatific state.
Read it as an apologue, my dear, this late,

persistent season of our separateness,
reminding us how far things drift unless

we tether them to fragile lines like these
affirmations of our shores' proximity.

An Amateur Barbarian

(Sir Richard Burton)

"An amateur barbarian," you called yourself,
aware, no doubt, of what the Greek word signifies:
the speaker of a foreign tongue. Your project, seen
by this light, would seem to have been the resolute
unlearning of your native tone, your Englishness,
in favor of the gruffer sounds one hears beneath
the midday sun at Mecca. But those gutturals,
so fully mastered that no *hajji* ever marked
an infidel at work, along with all your odd
arcana of the sands—the rapt oblivion
of dervish trance, the tantric gods, the kinky texts,
Somali double cicatrix and sly burnoose—
could not conceal, good Sir, the fact that you remained
professional, articulate, an Englishman.

The Beauty of Coincidence

As when, for instance, someone calls you up
not ten seconds after thought of them
went flitting through your mind; or when you meet
your neighbor in obscurest Timbuktu;
or buy a used book, open it, and find
its flyleaf blazoned with the signature
of an old friend living in a distant state;
that Jefferson and John Adams died
but hours apart, on Independence Day,
the nation's fiftieth; that on July
twenty-first, eighteen ninety-nine, Hart Crane
and Hemingway were born to mothers named Grace,
that both fought well, committed suicide:
no matter the degree or kind, all are
horripilating and remarkable,
enough uncanny so you want to make
brash annunciations to a dumbstruck world.

But lucky overlaps don't count as news.
The symmetries that boggle me will seem,
to you, remote and insignificant.
What then are we to *do* with them, these flukes
and useless windfalls—what even to *think?*
They feel too singular to just ignore,
dismiss, forget, and yet, by light of day,
are proven moondust and unviable.
Whether they're indicative of nothing more
than random hap, or of some demiurge
amused to sponsor serendipities,

it helps us little to hypothesize.
Perhaps the most that can be said is how
sweet they are, how pleasing to the core,
because they clarify, whatever else,
our sense of life as something meshed and merged,
of earthly links and eldritch parallels.

The Civil Wars

Of all the insurrections that the day
attempts to marshal into something like
a commonwealth, which of them—the quick
euphorias, the brave rushes giving way

so cravenly again to lassitude,
and that, in turn, to dread or fretfulness
(routed later by resurgent bliss)—
is final sovereign of the fractious moods?

Change, you are the savage general and the peace
most missed in times of stalemate; from each
debacle there's a transient release,

a treaty hammered out between the sides,
which, no sooner signed, is promptly breached,
leaving them lame, unled, and balkanized.

Hiroshima Without Adjectives

(after John Hersey)

The panic grass is pushing up
serenity into an air
that has at last regained its pale.

Above the burn, the feverfew,
the goosefoot stepping into view
among the Spanish bayonets.

The epicenter's blank is filled
as sickle senna radiates
its color outward to the world.

The painter's shadow pressed against
the wall he worked, his ladder too,
his brush about to dip the paint.

There is a man who drove a cart,
the space between his horse and whip,
and all the morning glories growing there.

Manhattan Piscatory

The other day in Central Park I saw
two boys while fishing catch, within an hour,
a heron and a snapping turtle.
Samaritans freed the beasts as joggers glowered

balefully, as if the pair had meant
to hook the wildlife—which plainly they hadn't.
I, for my part, neither scowled nor aided
but rather through my mind paraded

the metaphoric possibilities,
so piquant did the kids' dilemma seem.
Emblem of foiled desire? For Nature's ire
or grief a mordant wry synecdoche?

Whatever. Having cast your line in twice for fish
and hauled to land two quarries which
make you look a brute yourself, your only course
is to loose the prey, and from the pond retire.

Onomathesia

(Vico's term for Adam's naming of the animals)

The squirming ones came easiest: *worm,*
for instance, was the way his tongue recoiled
against its image in the dust; the oiled
flash of scales, the rustled grass, when turned
through his teeth became a whistling: *serpent.*
Other names, too, rose up and passed his lips
unbidden: *hawk* for the creature that tips
its wings to wind with force, *ox* for burdened.

But *woman* was the sound ambivalence made.
It opened out, this word, the fragile edges
of the narrow life he knew, worked a wedge
between himself and all the world; it frayed
away his faith. How could he form a name to fit
her solitude, and her love—what would he call it?

The English Are So Nice!

The English are so very nice
except of course when they are not.
They'll ply you with a lovely pot
of tea and scones, but then in a trice
kebab you with their rapier wit
and treat you like a piece of shit.
One minute it's a paradise
of tweedy charm, the next a wet
and caste-benighted oubliette.
But the English *are* so very nice!

[In 2000, The Paris Review *invited a number of writers to compose a poem to fit under one of six titles, then published the collective results as "Pomework: An Exercise in Occasional Poetry." The title I chose was "The English Are So Nice!" (which is taken from a poem by D.H. Lawrence).]*

Black Book

Her name I've kept for years beneath the S,
and shall continue to despite it all.
By now the entry is illegible,
or nearly so: three revisions of address,

of phone number a pair, and last month one,
profounder, from married back to maiden name
have left the whole page riddled with her change,
a map of midlife pandemonium.

Crumple it I should, as fate has done
to her of late, and just as casually.
But still I balk to edit out my friend,

as if to wrest her from the sibilants
and bump her up to clean, unravaged B
would be to censor what I can't amend.

Sortes Virgilianae

How odd, this swerve toward the oracular
each time the future flares with some great wish,
elusive as horizon; so that I pick
a random eclogue for my counselor,

my guide. "Say in what lands the flowers marked
with names of kings are born," it reads, "and you
shall have our Phyllis to yourself." That's true,
the Phyllis bit—there *is* a girl at stake—

but what am I to make of all the rest?
No need for more conundra here, for sphinx-
like koans leading to a final jinx.
Give me confirmation, please, a simple yes,

green lights ahead, to steel my tin resolve.
The brutal clarity of nix would do
as well, if so things weakly stood, although
could I then accept a forecast of love

clouded ineluctably? And there's the rub,
of course: we cannot keep the chafing will,
for fear of rain, snaffled at the window sill.
Volition breaks away and brings us up

against the puzzle of belief. Is fate
already written, published, canonized?
Or can our fumbling efforts to revise
check the narrative's mistakes, obviate

whatever miseries are chiseled there?
Ah Virgil, I should be scrying my surround,
perusing palms and guts and coffee grounds,
the birds' evanescent vectors on the air...

After all, you had the destiny of Rome
to mull and consecrate—big subject, that.
I can't expect my minor one to fit
into your scheme or make itself at home

two long millennia before the now
which finds me smitten and unclassical,
a far cry from a botanist. Still,
I'll give your floral cryptogram a go:

I say that flowers stand for thoughtfulness,
the kings' names for our own, and that the lands
in which they're born are none other than
these very provinces of glass, dear Phyllis.

The Sideways Medusa

(Basilica Cistern, Istanbul)

It went hardest on the snakes, that age
spent underwater: with no one left
to lithify, they lost their sense of mission,
grew sluggish and, later, restless at the myth
that binds them to my skull. I would have loosed
the poor things gladly, let them strike out
for the air. What good is power, after all,
if it can't uncoil its awful hair?

But when—the cistern drained—the first pair
of eyes slid down the column whose base I am,
and tilted to take in my slant, my lips
gone luxurious algae-green, I knew again
the dread astonishment a face puts on
as it finds perfection, then turns to stone.

The Aged Phoenix

(after the drawing by Paul Klee)

I find my once proud plumage dwindled now
to a paltry scruffiness of down; my wings,
which took the wind's dominion for their own,
droop dully on the bone, terrestrial
as the snakes my brittle talons used to pluck
so cleanly from the desert sand, and tear;
my eyes no longer lock on prey the way
they did; my thin legs quail; my beak is cracked.

It's not supposed to be like this, the old
phase lingering, its half-millennium
petering out in Arabian heat.

That the next parousia will come
is guaranteed—but when, along which path,
and with what promise lifting from its ash?

The New Parnassians

(for Herb Leibowitz)

That this is the way it's always been done—
the old devolving to the grateful young

the gold of their experience, the green
gleaning off the seasoned their maturity—

subtracts but little from my debt to you.
My burden grows, in fact, because so few

now trouble to pass on, without reward,
the living knowledge they inherited.

And culture too, and history, are deep
in hock to those who make tomorrow keep

alive the verities of yesterday.
Such patrons are deserving of a place,

a peak, beside the muses they abet—
they who teach us what we'd otherwise forget.

From the Republic of Women

Like Friday's footprint in the total sign-
lessness of Crusoe's solitude, her step
confirmed that corridors I had kept
bare could bear another's tread again.
She wandered there, along my vacant hall,
down the coiled declension of my stair,
and having travelled through all rooms declared
her gift deductible, my import stale.

Such are the customs of gynocracy:
by slow inspection of your bags they spot,
to mutual dismay, the same old contraband
you've stashed before and thought you'd thrown away,
the kind of hard, unyielding coconut
that lands you back in immaculate sand.

Fermat's Last Theorem

I have a truly marvelous demonstration of this proposition
which this margin is too narrow to contain.

—*Pierre de Fermat, 1637*

$x^n + y^n = z^n$ *has no solution where n>2*

I have written a wonderful poem
which this page, alas, cannot contain;
in its place, accept a lesser one
—proving nothing and provisional as rain—

about the very absence of that first,
aforementioned work, whose triumph was to fix
the incongruity of life and art,
those twin perfections (known as y and x)

our poets have presumed unsquarable.
I'd quote it to you if I could fit,
within these lines, such mighty algebras;
you'll have to settle for a surrogate

instead, a flat, misfractioned aftermath
suddenly no longer able to defer
admitting to its solitary state.
For I have never solved the integers

(as claimed in stanza two), nor cubed the crux
of things into a grand equation;
I trust you're not offended by my ruse,
the clumsiness of my evasion.

Please understand: I needed to pretend
my ideal harmony already clinched,
its riddling sequence neutralized; only then
could I put down, progressing inch by inch,

the hesitant notations that you see
now straggling lamely toward an open end.
It's not the code I'd hoped, the stalwart z
Pythagorean in its powered n;

but still it manages at least to squeeze
into the finite series of my time,
my mind, my page (to name three brevities)
the long solution of a perfect rhyme.

Scruples

Chipped off the Latin for
"small sharp stones," they are
those irritants that get
into our shoes and sting
our feet until we stop,
stoop, and dump them out.

The Calligraphy Shop

My God, they were all so beautiful,
each parchment trumpeting its cursive praise
of Allah, whose residence in Istanbul

seemed tenuous throughout the vulgar maze
of kitsch and gizmos the Grand Bazaar's become.
Here at last, I thought, He'd find a phrase

or two to please Him—not the vendors' dumb,
kilowatt promotion of their crap,
but silent decibels of script, its un-

or otherworldly characters trapped
in suspended eloquence. As if on ice
a figure-skating rubricant had mapped

his arabesques with slathered blades, the rise
and roller-coaster dip of letters swelled
even past my ignorance; my eyes

alone could estimate, yet not quite melt,
the igneous devotion frozen there.
Did it matter exactly what they spelt?

Arcs, crescents, diamonds punctuating the air
above them: an abstract caravan
of lines carried over crystal-clear

its cargo, the sweet imbroglio of man
and deity snagged (I romanticized)
within those desert skeins. The Koran

fanned out across the walls in bearably sized
divisions of its heat, the surahs all
cooling under glass—some plain, some surprised

alchemically into animals.
There were verses crammed to fit a camel's back,
Kufic exhortations strung along the tails

of tigers like a lash, delicate black
songbirds caged in painstaking minuscule,
and, beside them, brute raptors shellacked

to paper by religion. Such midnight oil
they must have torched, these anonymous
masters of kinetic penmanship, such toil

lavished on the strictly frivolous!
But would their occidental counterparts
have recognized the brotherhood of bliss

between them, the consanguinity of art,
or would the monks behind the Book of Kells
have cried for heathen blood and torn apart

their genius as the stuff of infidels?
As I was pondering this, the store's
proprietor approached, offering his help

in that skewed, courtly English foreigners
can so disarm us with. He laid out
his treasures patiently: which ones were

Turkish, Urdu, what they were about,
the deep antique and the relatively new.
Then, perceiving my attention caught

by a small one high up on the wall, he drew
it closer. Although less extravagant
than others, it fascinated through

sheer obsessiveness, for the inscription went
hypnotically snaking down a gyre.
"Ah yes," said my host. "It's Kurdish, meant

to rid a house of demons, *djinn*, whatever
pesky spirits skulk around. Place a bowl
beneath it, then wait for ghosts to gather.

They will amass, unable to control
their belletristic curiosity.
Once they start to read they'll read the whole,

the spiral pulling them inexorably
toward its center, from where they drop
into the dish—now disposable, you see."

And so was I. Powerless to stop
gawking at the paranormal bait
before me, suckered by its agitprop,

toppled by an agile nib, I let
my skeptical guard fall peacefully. Outside,
a muezzin was warbling, from his minaret,

torrid plangencies of prayer and pride
upbraided, his spectral keening parallel
or woven with the printed one I tried,

but failed, to resist, susceptible
as I was that blazing August afternoon
to the Byzantine embellishments of quill

searing the mere vellum. I've come to burn,
since then, with a greedy rage to reproduce
its tyrannies, inflicting in turn

(on fellow ghosts) capture, jail, the gentle noose
of amazement; I've come to hunt its cold,
fatally calibrated charm, its ruse

of hanging there in ambush, growing old.

Notes

4. The "black ox" is a Renaissance figure for melancholy. See, for instance, Fulke Greville's *Life of the Renowned Sir Philip Sidney.*

18. "Basinet" (a kind of helmet) should not be confused with "bassinet" (a kind of cradle).

28. In *Hiroshima,* Hersey writes that, "The bomb had not only left the underground organs of plants intact; it had stimulated them.... Especially in a circle at the center, sickle senna grew in extraordinary regeneration...." He also reports that "the bomb had, in some places, left prints of the shadows that had been cast by its light.... A few vague human silhouettes were found, and these gave rise to stories that eventually included fancy and precise details. One story told of how a painter on a ladder was monumentalized in a kind of bas-relief on the stone façade of a bank building on which he was at work, in the act of dipping his brush into his paint can; another, how a man and his cart...were cast down in an embossed shadow which made clear that the man was about to whip the horse."